Cigarscapes

by Philippe Mesmer

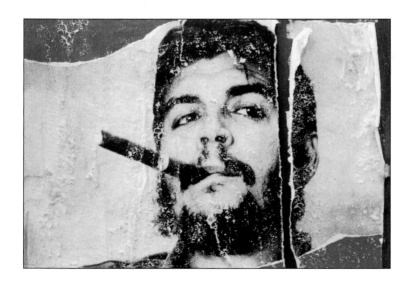

Publishing Director: Jean-Paul Manzo
Text: Philippe Mesmer
Translation from French: Mike Darton
Design and layout : Cédric Pontes
Cover and jacket : Cédric Pontes

We would like to extend special thanks to Mike Darton
for his invaluable cooperation
We are very grateful to the Cuban Tourist Office in Paris.

Photograph credits:

© Cuban Tourist Office in Paris: p.

© Parkstone Press Ltd, New York, USA, 2001
Printed and bound in Hong Kong, 2001
ISBN 1 85995 835 4

Introduction

'A woman is only a woman, but a good cigar is something rather special' Rudyard Kipling didn't quite say that – for all that he was an excellent writer – but he was very much a man's man. And for such a red-blooded male, women and cigars both belong to the heady domain of personal pleasure. A pleasure that is both noble and elegant gratifies the senses with its delicacy and refinement. The mere mention of the word 'cigar' may be enough to evoke a whole panorama of mental images and arouse the Epicurean that otherwise lies dormant in all Havana-cigar-smokers.

Such mental images all have a feminine counterpart. The colour of the cigar comes first. It may be comparable to a smile, a look, even the view of a body comfortable in the knowledge of its own beauty and incontestable charm. It may hold the promise of the exotic, the racy, the warmly smiling.

Then there is the smell which, in its turn, assails the nostrils of the willing victim. Just as a perfume has its own characteristic fragrance, the smell of a cigar is indissolubly linked with its colour. It may be strong and pungent, or it may be discreet and even weak. And it comes from the Caribbean where, perhaps – just perhaps – the women who make the cigars practise the strange custom of rolling them on their thighs ...

3

Such seductive qualities conspiring together so shamelessly nonetheless eventually lead the smoker to the stage of testing the cigar by touch. From tip to toe he caresses the body of the cigar, much in the way he might stroke the smooth skin of a woman. He enjoys the sensation, savouring the promises it seems to make him – and to which he will undoubtedly hold it, for a cigar cannot be unfaithful.

When the magic has had its effect, it is time for the smoker to cut through the tip. This 'circumcision' performed with despatch, not to say panache, he lifts the cigar at last to his mouth. And he lights it. What follows is escape, release, euphoria – a level of pleasure that perhaps only a woman would otherwise be able to bestow . . . if she wanted to.

Floral themes are commonly represented on cigar-box labels. This one shows a tobacco plantation with palm-trees in the background.

A woman making a cigar in a cigar factory; photographer unknown.

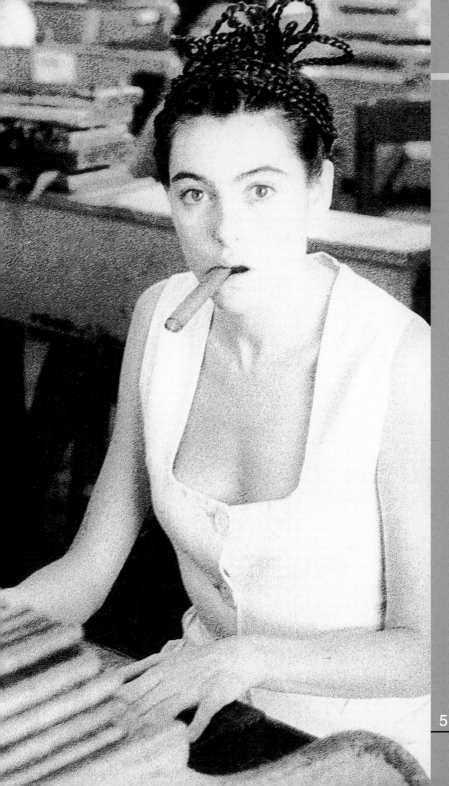

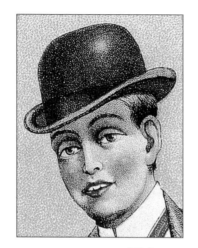

Beauty in the eye of the beholder

A man associates women and cigars with the attainment of pleasure. When he grasps his favourite type of cigar, he cannot but conjure up in his mind a picture of the woman who rolled that cigar with such precision, with such spirited warmth.

A late Victorian gentleman of leisure – an appreciater of elegance and of fine cigars.

She appears in his thoughts, sometimes, rolling the cigar on her half-opened thighs in a sort of spellbinding wantonness. In a way, she is like the smile on the face of a ghost: part of the existence of the cigar before the smoker has even tested its qualities. She belongs to the world of the cigar and to the mythology that surrounds it. The Cuban cigar-rolling woman has actually become a cult object.

The novelist Herman Melville once wrote that Cuba's climate gives the tobacco the best aroma in the world, and gives the Cubans the best skin. But before testing the aroma, the smoker should study his cigar's qualities by means of its colour. For a cigar in its variously-coloured layers and textures readily reveals just as much as might be inferred from the varying coloration of the skins of the women who contributed to rolling it. Such variations in a cigar result from the differing strengths of the tobacco used. A light-coloured leaf makes for a light-coloured cigar. Its light but strong quality comes from the early harvesting of the leaves before they are properly mature. They are then quick-dried, either over a wood fire or with a naked flame. (The result is the *capa candela*.) The lightest-coloured cigars are categorized as *claro*, or even *claro claro* if there is also a greenish tinge. The spectrum that starts here then runs through yellowish brown toward dark brown: the *maduros*. The darkest of all are further described as *oscuro*. These comprise leaves that have been uppermost when growing, subject to the vicious heat of the sun, and in which fermentation is already well established.

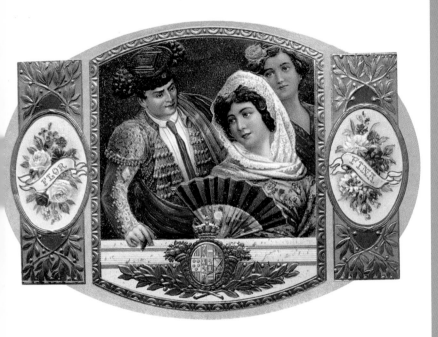

This label of unusually fine design and with excellent gold-leaf decoration is from a box of Flor Fina. Redolent of Latin-American charm, it depicts a scene of seduction under a sultry sun.

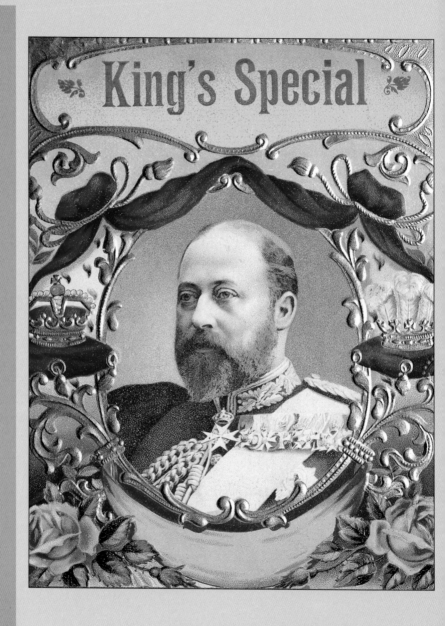

King Edward VII of Great Britain.

Woman with cigars; from a painting by Numa.

The greatest pleasure of all for a red-blooded male: getting away from it all with a cigar after a hard day's work

The range of colours from which the smoker may make his choice also has something of the feminine about it. The fair and sophisticated is as seductive as the deepest, darkest brunette-brown. Cubans with their soft skin, their gentle characteristics, their generous hearts and their joyous festivals are the inheritors of a rich mix of cultures. Both señoritas from large *haciendas* and dusky daughters of African slaves have become the bewitching Cubans who today meet together on the Malecón, the road along the shore at Havana, or in the bars such as the Bodeguita del Medio, where Ernest Hemingway used to wet his whistle with a *mojito*.

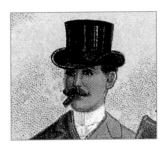

Such women have cast their spells there for a long time. Those who roll cigars are the most celebrated of them. The French writer Pierre Louÿs, famous at home for the levity of his phraseology, rendered them due homage by penning these lines:

Yes, there were certainly some skinny little bodies among that weird assortment of humanity, but they were all interesting. And I stopped short more than once at the sight of a shapely woman's figure. [. . .]

A warmly passionate upper body, nicely rounded, with the velvety sheen of a fruit and a skin coloration that was bright and clear and deep, from which jutted – with some élan – both the armpits clothed in curly astrakhan fur and the darker tops of the swelling breasts.

After 1914 the cigar-band became a medium for advertising.

Winston Churchill, a noted cigar enthusiast. It is said that during the Blitz in 1940, when a bomb destroyed the house of Dunhill in London, the manager immediately telephoned Churchill to reassure him that his personal reserve supply of cigars remained perfectly safe.

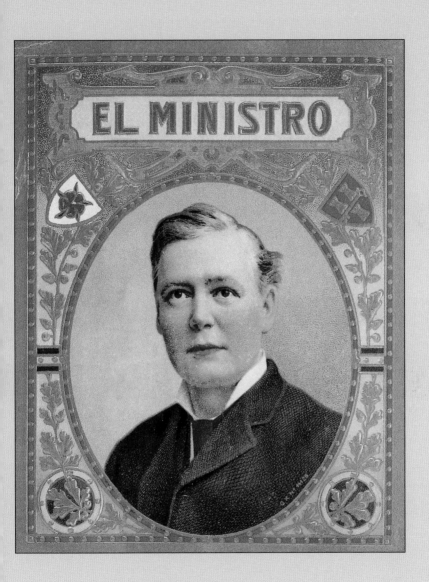

Pleasure for the eyes

From their various ancestors, the women of Latin America have inherited a taste for bright colours, and plenty of them. A cigar that might

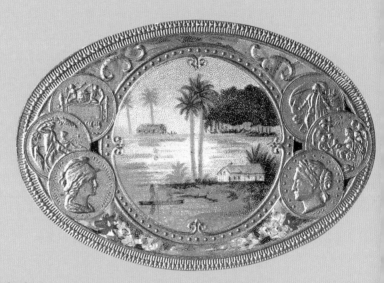

An exotic landscape wafts the cigar-smoker off to Havana cigar country.

A worker sorting tobacco leaves in a Cuban factory.

appear sombre and even dull in its encasing covering must put on its most eye-catching dress to ensure that an air of delicate decadence is the overall effect produced. The cigar-band is then attached to it, like a decorative garter on a shapely leg, to give it an even more attractive allure.

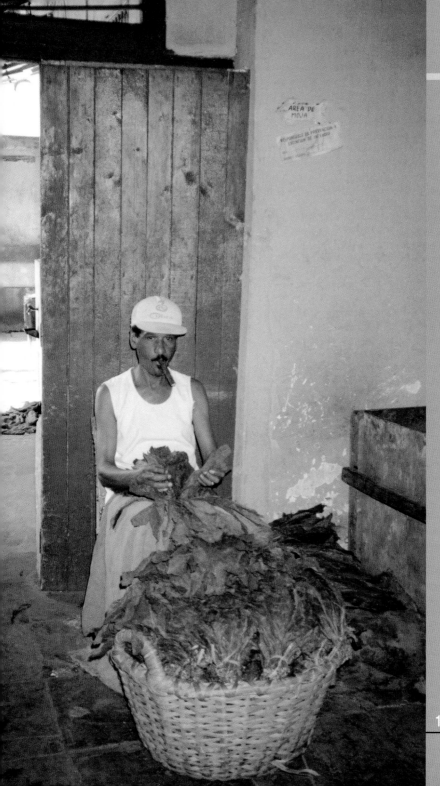

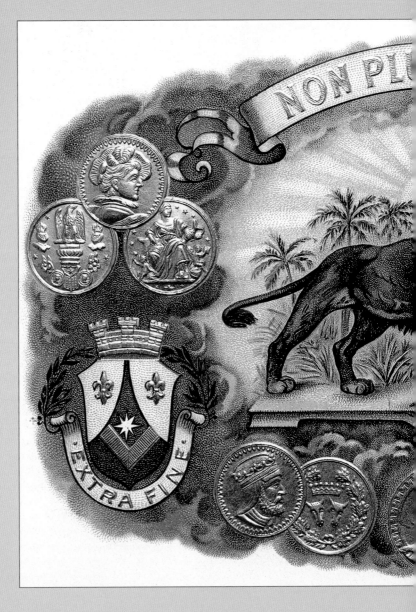

This cigar-band combines exotic representation with exceptionally fine gold-leaf decoration.

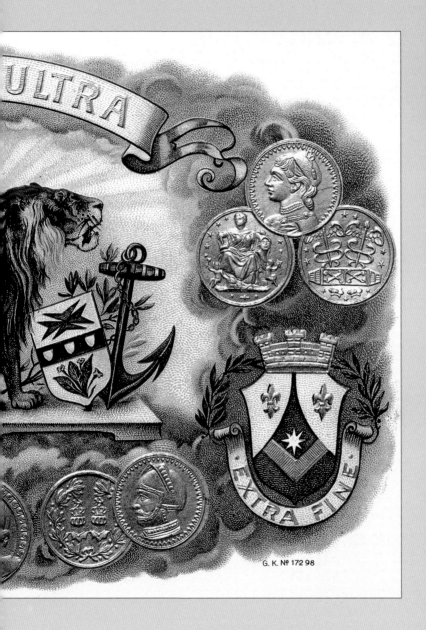

ULTRA

EXTRA FINE

G. K. № 172 98

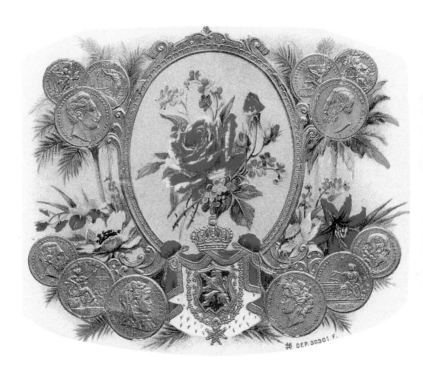

The four labels here and on the next page are pretty much variations on a single theme – the rose: source of inspiration for poets, and the queen of flowers.

Such elegant garb – formerly of silk rather than the paper of today – was itself in due course fashioned with the utmost refinement, becoming yet another enticing element of seduction. It was thus that Hemingway could send a cigar-band to film-star Ava Gardner as a souvenir of their first meeting.

It is in lofts like this that the tobacco leaves are dried before being made into cigars.

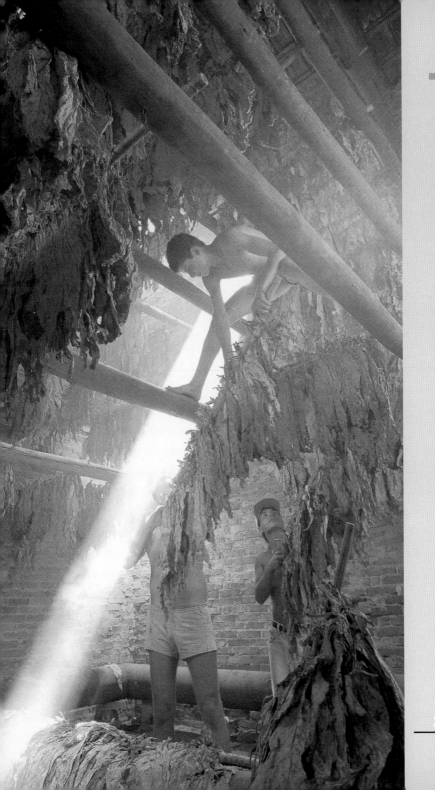

More than embodying the signature of the maker, the cigar-band has for many decades also carried portraits of great smokers of the past, such as King Edward VII and Kaiser Wilhelm II. And it has likewise formed the stage on which many a beautiful woman has been presented. The series of Ballerinas produced in 1902 by the Jockey Club of Barcelona featured the delightful spectacle of a bevy of gorgeous girls dancing in short ballet-skirts . . .

In the prude old days of England under Queen Victoria – when the legs of grand pianos were kept covered so as not to arouse lubricious thoughts in men unaccustomed to the sight of anything higher than an ankle on a woman – a cigar-band depicting scantily clad ladies might represent a wonderfully depraved glimpse of the forbidden . . .

But the cigar-band was by no means the only form of decoration to cheer on the smoker as he took up his cigar. The cigar-box – generally constructed of cedar wood – bore a label or picture which, like the cigar-band, might feature a wealth of imagery. In a spectacular way, and one that would not have displeased such a nobly decadent personage as, say, the French writer Charles Baudelaire, the box customarily displayed stylized scenes of love, of seduction – of pleasure, then, always of pleasure – but pleasure for the eyes.

The Scent of Legends

Like a pretty woman, a cigar is very capable of attracting attention. It uses its aromatic qualities, for it knows the potency of the sense of smell. Isn't it the most primitive of all the human senses? Like a woman, a cigar wafts through the air a variety of subtle scents which titillate the nasal passages most agreeably, even occasionally giving rise to a type of intoxication. The power of the aroma depends on the strength of the cigar, and therefore its coloration.

With skill and patience, the cigar-makers roll cigars by hand, one by one.

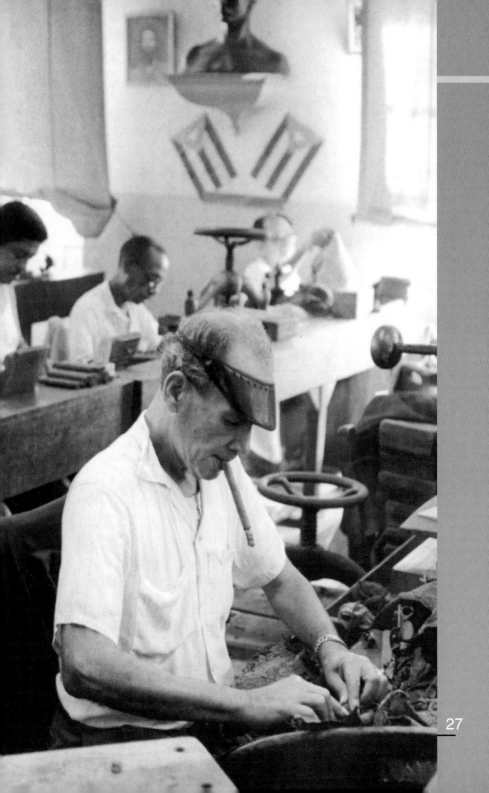

As has been the case with the best plants since the first tobacco plantations, one of the most important factors for obtaining the finest leaves is the nature of the soil in which they grow, and from which they can absorb the many scents and flavours that they eventually contain. Such an area of prime tobacco growth is the Vuelta Abajo (the 'Lower Circuit'), in the province of Pinar del Rio in western Cuba. The most sought-after leaves are the product of the villages·of San Luis and San Juan y Martinez. Their superior quality results from the presence there of a stratum of sandy subsoil. It is from this area that the very best Havana cigars come.

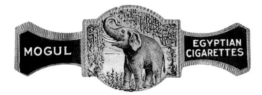

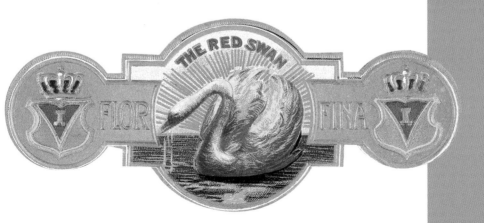

Animals and birds comprise an immense subject for cigar-bands and box-labels – cockerels, swans, horses or even deer may be depicted on the bands, making them veritable works of art.

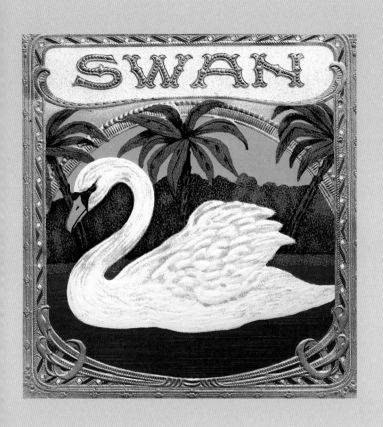

Under the tropical sun in the Caribbean humidity, the plants are trained skywards. They absorb the multiplicity of scents that enlightened cigar-lovers later rejoice in detecting. Different schedules for harvesting the leaves result in the different types of cigar. In Cuba no fewer than 960 different sorts are produced.

Cigars are sold in cedarwood boxes – cedarwood because of its special properties in retaining the humidity in which the cigars must be kept.

In his book, written in French and entitled simply *Londres* ('London', 1933), journalist Paul Morand described one establishment in Jermyn Street:

From beneath arose the ammoniacal smell of cigars. A corridor full of Havanas all bound up in yellow silk led on to the humidor, a largish room lined with cedarwood and reserved especially for the conservation of 'green' cigars . . .

Like a refined dish or a wine with a rich bouquet, the aroma of a cigar is quite capable of arousing appetites.

Such an aroma is generally described, like wines, in terms of strong natural scents. From an odour that may be fresh and acidulated to one of hay and the stable, passing at the halfway stage through one of liquorice or peppermint, cigar-lovers use any number of evocative similes to represent the olfactory charms of a type of Havana cigar that they are about to smoke for the first time. It must pass the test initially of the eyes and then of the nose. After that, it is surely time for the ultimate test – that of the loving caress.

The deft touch

Tactile pleasures :

Before it is lit, the cigar has first to be inspected, sniffed – and then felt. The ritual seduction then proceeds apace. The eyes, then the nose, and finally the tactile nerve-endings in the skin fall under the spell. The cigar is fondled from its tip to its toe. Its elasticity, its lithe suppleness are evaluated and appreciated. Its aroma diffuses through the fingers. Congress begins, little by little. As if caressing the body of a woman, the smoker allows himself to experience the sensuous pleasure of physical contact with the 'skin' of the cigar. He gazes with infinite tenderness at the outer casing, which like real skin, can make senses swim and inspire dreams ...

Once they have been rolled, the cigars are stored in ideal conditions of light and humidity before being packed in cedarwood boxes ready for sale.

Dealing with the surface features of a cigar is part of the whole ritual of smoking. The smoker may choose whether or not to 'de-band' his cigar. There is no special rule that applies. The French author Stéphane Mallarmé once described his great pleasure at being given, at the end of a meal,

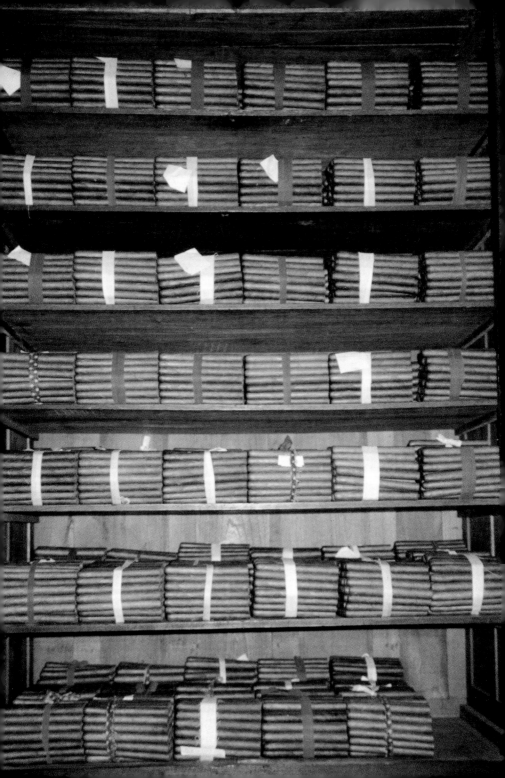

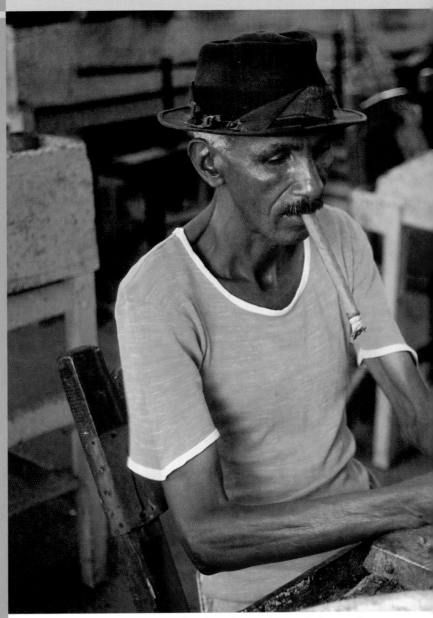

Workers in cigar factories are almost all cigar-smokers themselves. 'Rolling your own' takes on a whole new meaning when they do it.

Cigar-bands and box-labels can depict scenes that are quite romantic, in which case they generally feature softer colours – like those of a women's face . . .

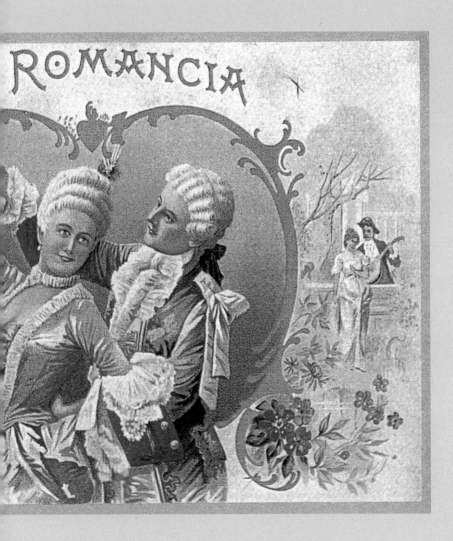

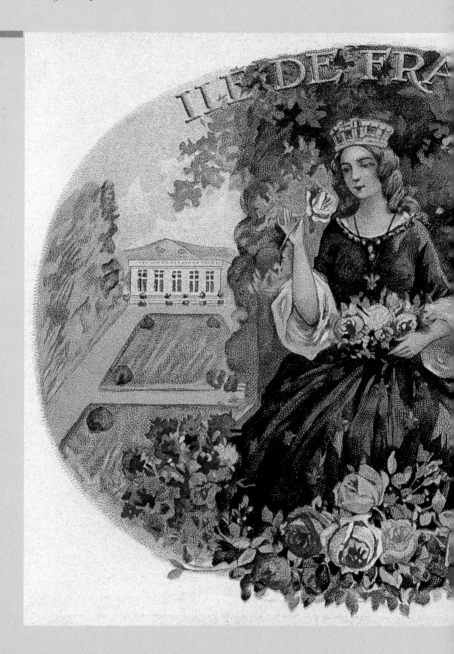

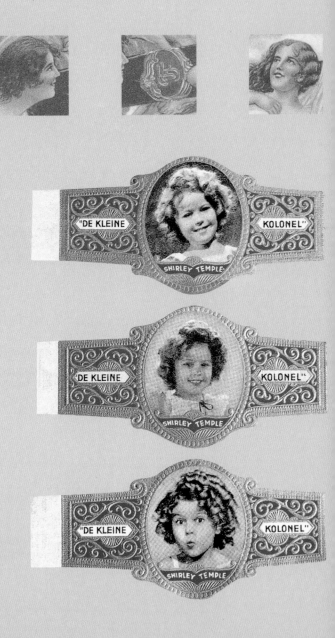

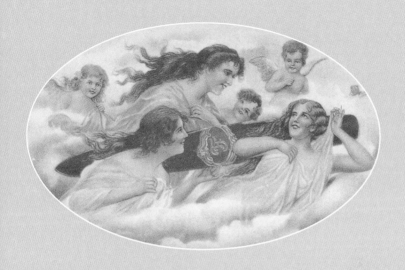

ten boxes of gleaming cigars – Valle, Clay, Upmann – and from those boxes displaying ballets to be danced in times to come by pretty women, I denuded the cigars of their cigar-bands. For that is the proper way of doing things …

Conversely, Paul Bourget wrote:

The count, as refined a man as they come, [stubbed out] the cigar he had smoked half of, taking care to destroy the cigar-band that remained attached to it.

A cinema chain in Amsterdam put in an order for a series of cigar-bands depicting Shirley Temple on the occasion of the release in Holland of the David Butler film The Little Colonel in 1935.

43

Making the cut

When he judges that the moment has arrived, the smoker may make the incision. In his publication *The Book of the Cigar Connoisseur,* Zino Davidoff refers to the absolute necessity of a smallish cut, made carefully, proportionate to the cigar, enough to allow the smoke to come through in fair quantity – abundant, but not too much.

There are several ways in which the incision may be made – some far more elegant than others. American smokers tend to use clippers, which are not exactly the soul of refinement and which turn an activity requiring deft precision into something all too haphazard. Infinitely more stylish – and more precise – is the use of the fingernail. If the fingernail is long and carefully-pared, and if the cigar has been kept in exactly the right conditions of humidity, the operation could not be easier. If the cigar is a little dry, lightly moistening the tip should make it tender enough to pierce accurately.

If the smoker wants even greater precision – an aperture with an even cleaner outer surface – there are several instruments for the purpose at his disposal. There is the cigar-cutter, a sort of little guillotine which punches a bevelled slit or a conical hole into the tip, and must be used with special care. Or there is the lancet or cigar-spike, with which the smoker risks making too deep a cut and so drawing in mouthfuls of scorching-hot smoke.

In every case, steady firmness of action is essential.

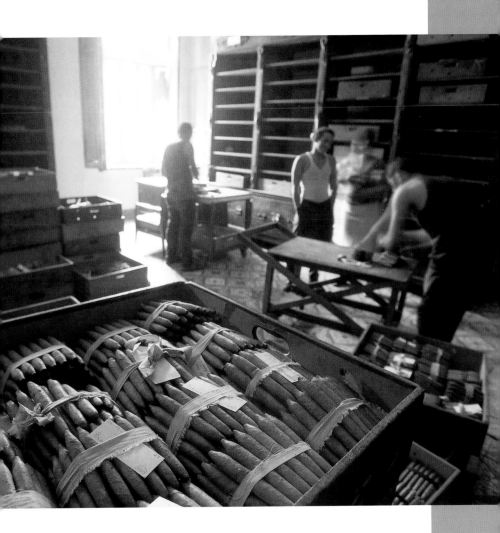

Cigars stored in a bonded warehouse.

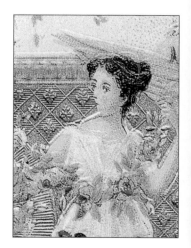

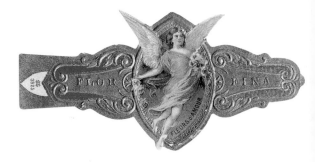

This series of winged angels was issued by Hermann Schött for La Nobleza cigars in Canada.

COUPE DE FAUNE

A touch of flame

Just as in making the incision, lighting the cigar requires care and dexterity. The cigar is in the mouth. The flame is brought near. But that flame should never derive from a petrol lighter nor a sulphurated match. It should be small, and applied to the end of the cigar from one side. The idea is to create an area of fiery heat in the middle of the cigar that then spreads evenly outwards to the under-casing leaves and finally to the outer casing. On that subject we might profitably hear the words of Davidoff once more, who described lighting up as an activity requiring both seriousness and discretion, precision, but not solemnity; a procedure demanding deliberation without a hint of exhibitionism.

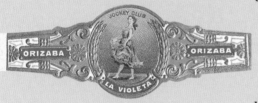

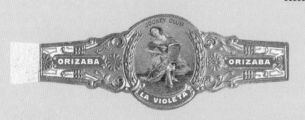

This series of ballerinas was produced for the official reunion of the Barcelona Jockey Club in 1902. It is considered the ultimate prize and glory of cigar-band collectors.

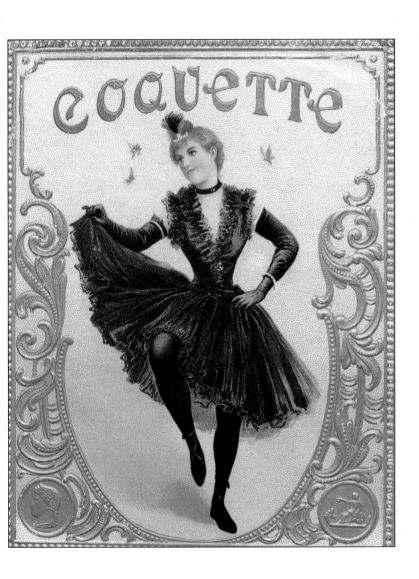

A matter of taste

Should you smoke your cigar alone or in company? Well, if you believe that a good cigar is an excellent companion by itself, your first thought will doubtless be that it is better to smoke alone so as to make the most of it. But it's equally possible for friends to come together to smoke cigars in contented fellowship. After all, what could it be but a pleasure to offer one or more of your closest friends the precious, if shortlived, experience of a superb cigar? The satisfaction you take in being the giver will then add to the general euphoria you feel as you get away from it all together. Words become all but unnecessary. A haze of drowsy contentment hangs over your group of aesthetes. No irritating distractions. The occasional comment – always light-hearted and expressive of personal well-being – is greeted with congenial smiles. Ah, yes.

Henri de Toulouse-Lautrec, Portrait of Mr Louis Pascal, 1893

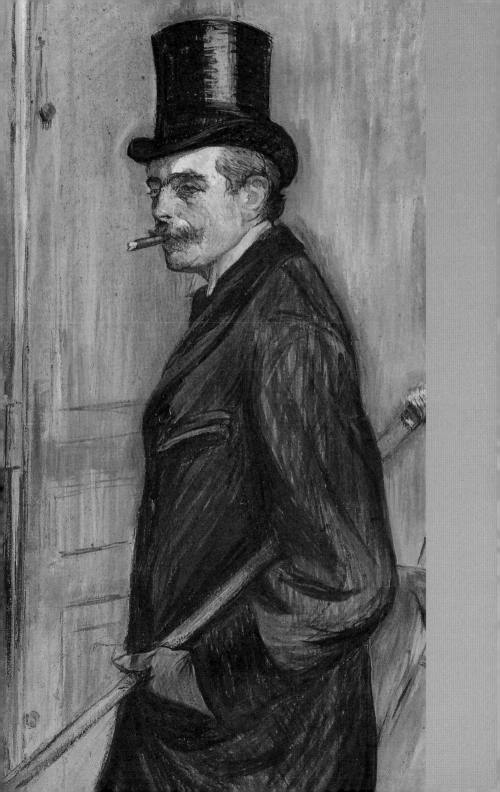

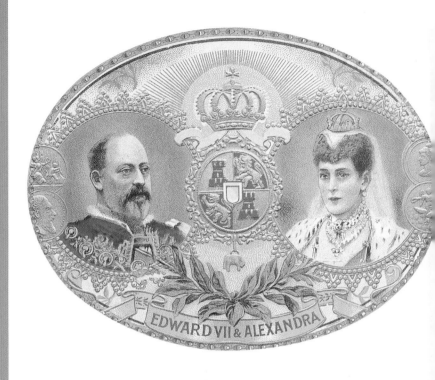

Cigar-bands representing, variously, Albert I, King of the Belgians; Queen Wilhelmina of the Netherlands; King Alfonso XII of Spain; and Napoleon Bonaparte.

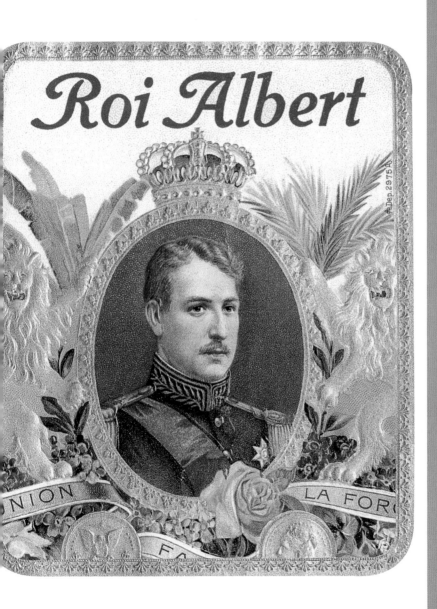

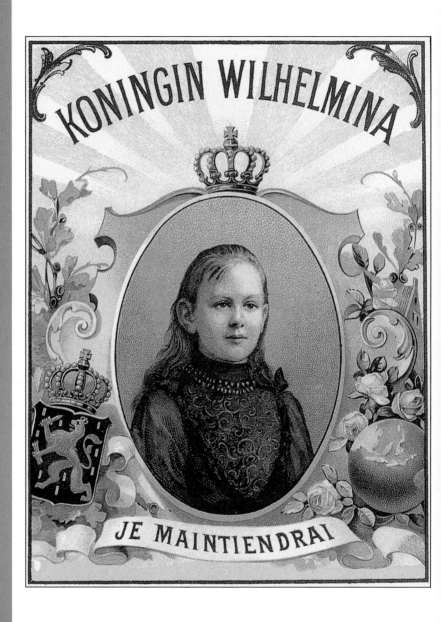

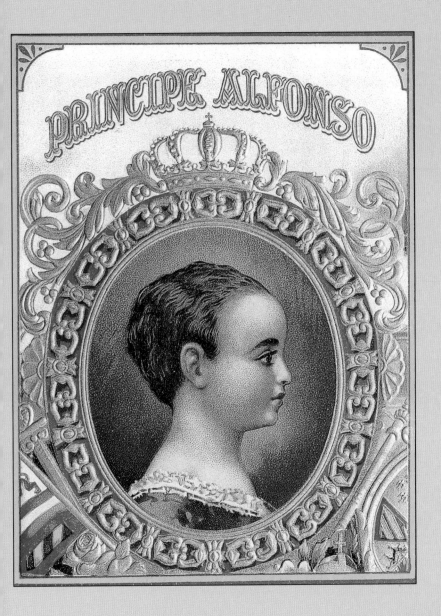

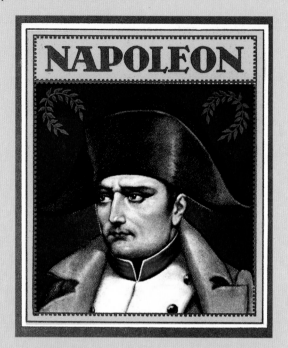

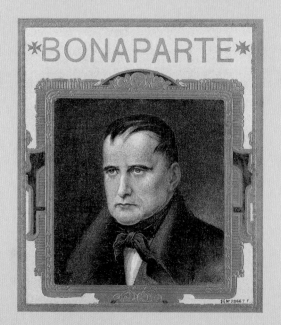

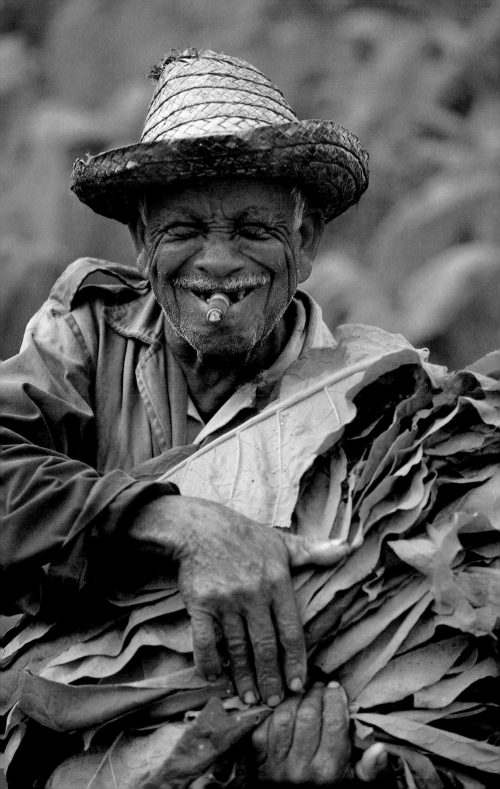

JOFFRE

Président Poincaré

POINCARE

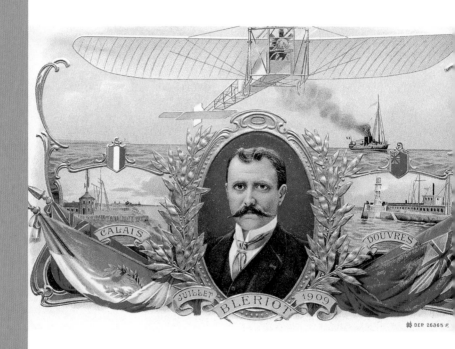

The history of aviation is magnificently recorded on cigar-bands. Above, the French industrial engineer and pioneer pilot Louis Blériot successfully made the first flight across the English Channel on July 25, 1909.

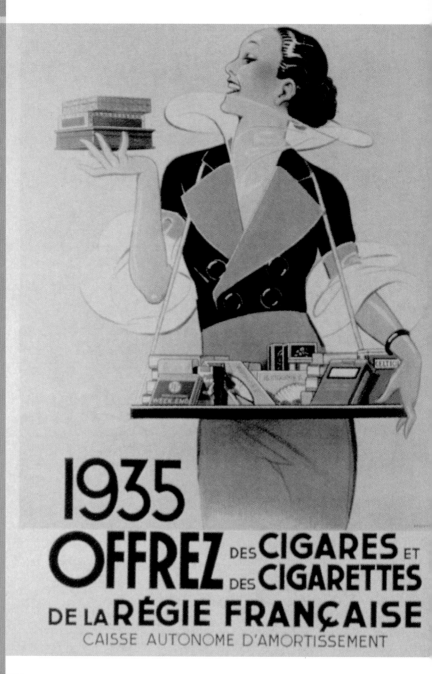

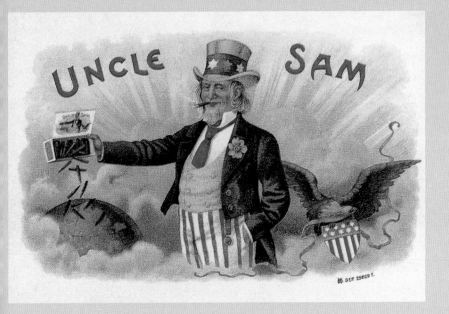

Going solo

On the other hand, comfortably installed in his leather armchair amid surroundings that emanate total peace and quiet, the cigar-smoker can abandon himself to his hedonistic enjoyment. He allows his mind to wander where it will, influenced by the cigar's bluish swirls of smoke. In a slight but euphoric haze, his imagination runs free. The aesthete in him delights in the mental images that parade before him, evoking memories, sensations and emotions.

Publicity label advertising the French Tobacco Corporation, 1934.

US Presidents and great moments in the history of the United States both feature strongly on cigar-bands.

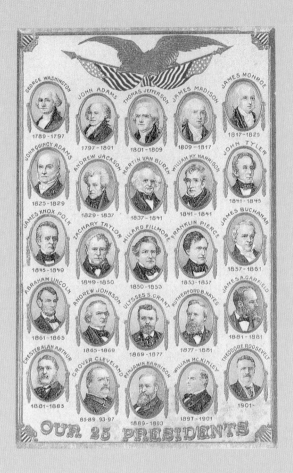

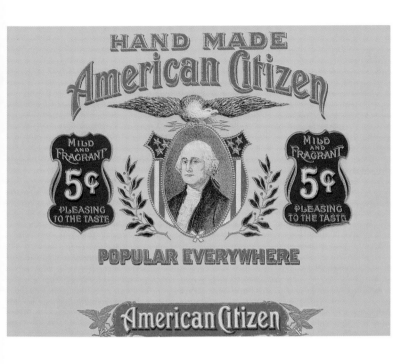

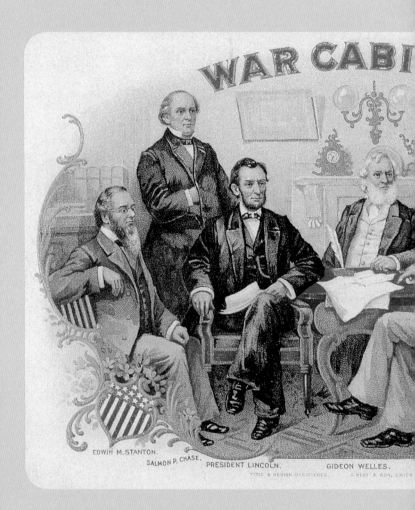

EDWIN M. STANTON. SALMON P. CHASE. PRESIDENT LINCOLN. GIDEON WELLES.

EDWARD BATES.

M H. SEWARD.
MONTGOMERY BLAIR.

EDWARD BATES.

But he is not overwhelmed with pleasure. It is simply there. It is accompanied by vivid recollections of women he has loved – whether or not he should have – blonde or brunette.

Such whimsicalities bring him back to thoughts of Cuba, the women who roll the cigars there, the benevolent thigh against which was rolled the cigar that he is savouring at this very moment. He smiles wryly, recalling Monica Lewinsky and President Clinton's special use for a cigar. His thoughts turn towards his friends, imagining cigar-smoking sessions in the smoking-room of an English manor-house in the evening after an excellent dinner.

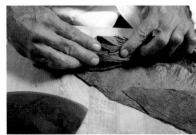

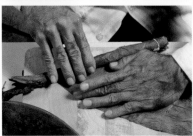

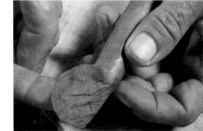

Different stages in the making of a cigar.

A Cuban street view.

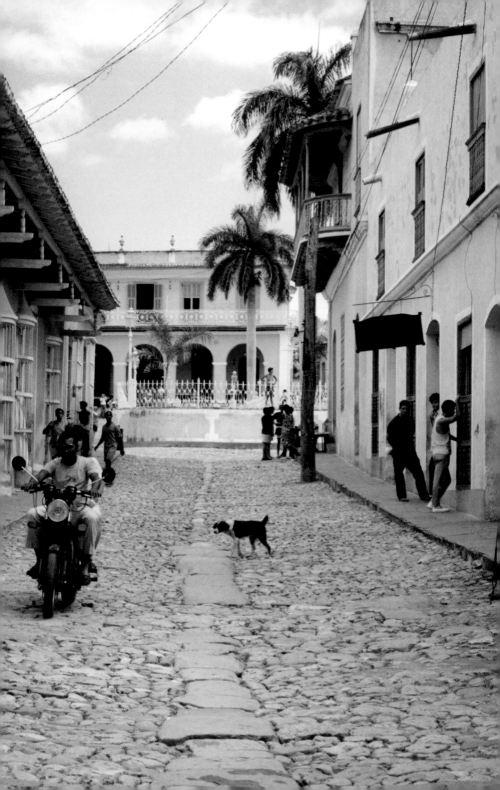

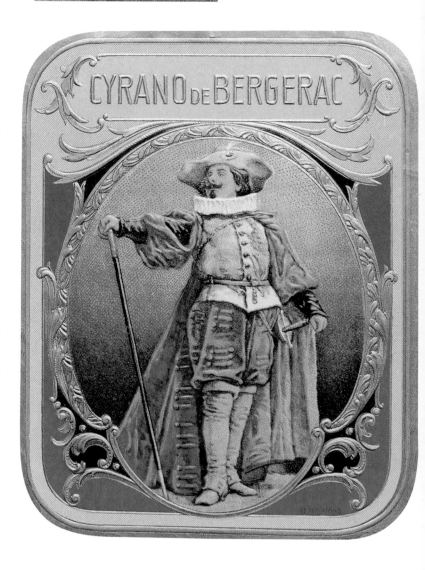

Great literary heroes have found even wider public exposure in various series of cigar-bands.

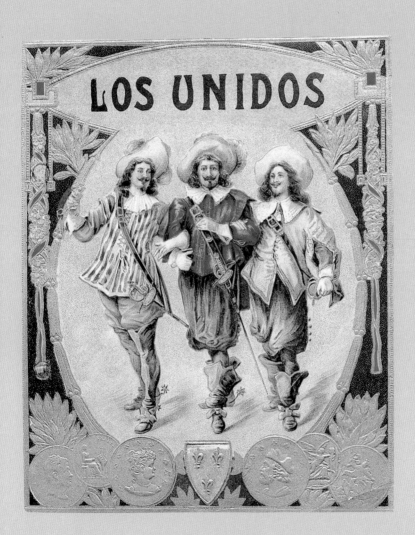

He runs his mind's eye over some of the most renowned cigar-smokers – Winston Churchill, Chancellor Bismarck, the painter Raoul Dufy (whose canvases were sometimes paid for in cigars), the French psychoanalyst Jacques Lacan (who advocated the smoking of those 'spiral' cigars, the Cuban culebras), Hemingway, Che Guevara, Fidel Castro, and so many others, nameless and otherwise, who share, have shared, and will share the same passion.

He decides to be fair, and spares a thought for those women who have been bold enough to declare their liking for cigars – Geraldine Chaplin, Sharon Stone, and the author George Sand (born Aurore Dupin) who once shocked the Russian aristocrat W. de Lenz to the extent that he exclaimed fiercely, 'There is no salon I have been to, madam, in which a woman of taste has smoked a cigar!'

Hot sunshine and a rich soil of just the right type provide excellent growing conditions for the tobacco plants.

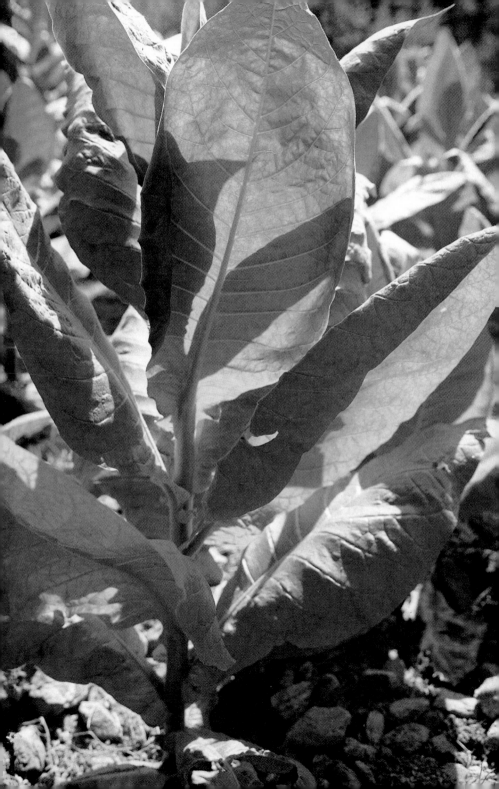

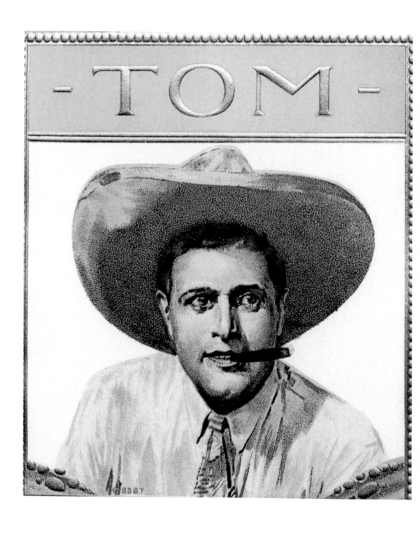

Tom Mix, one of the early silent cinema's Wild West favourites.

Musical instruments and famous composers have also inspired cigar-band designers.

TITLE & DESIGN OWNED BY YORHANA CIGAR CO.

Combined tastes

Our smoker might well also think of
consuming a little alcoholic beverage with his
cigar. Ernest Hemingway used to intersperse
his cigars with slugs of rum. But combining
cigars and alcohol is a matter for caution. An
Upmann No.2 goes well with a superior Scotch
whisky. Calvados, on the other hand, goes well
with cigars that are rather less strong.

Nº 20788

Expecting guests, our smoker may be bright enough to take care to choose cigars corresponding to the type of meal with which he means to regale them. Zino Davidoff has stated that after a meal a cigar 'should be the heavier, the more long-lasting, and the more compact the more highly-seasoned the meal itself has been in its meats and its sauces.' Such decrees should receive general application, coming as they do from true connoisseurs. Nonetheless, the choice of cigars (and of meals and drinks) remains always that of the host.

Cuba is a land full of colours.

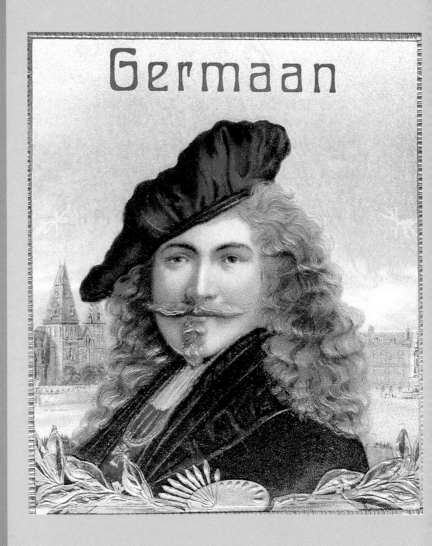

Many celebrated artists have been further immortalized on cigar-bands.

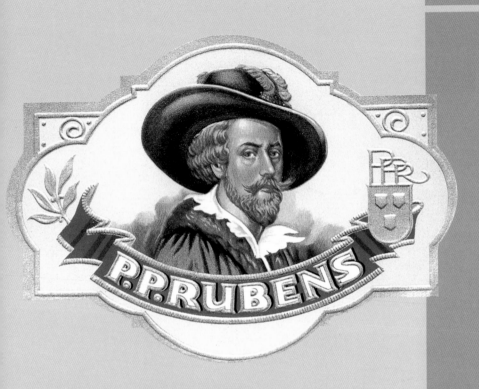

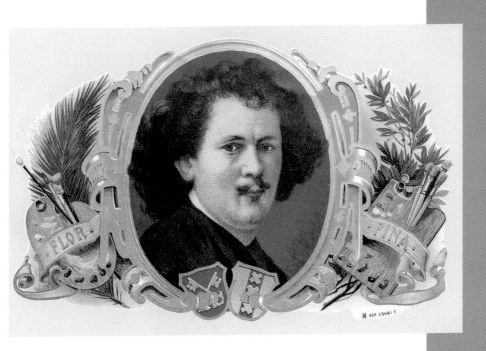

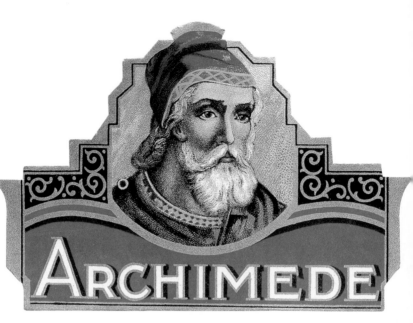

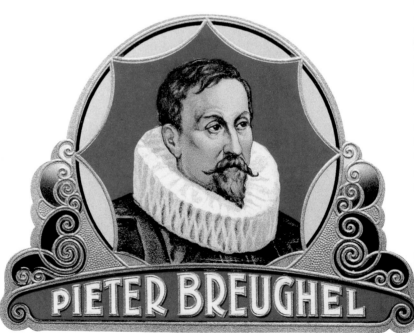

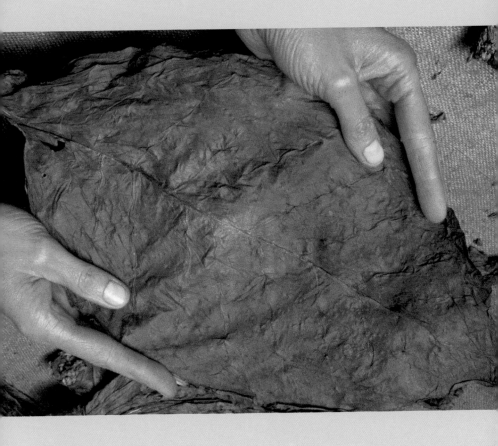

The outer leaf that encases a Havana cigar must be carefully
selected.

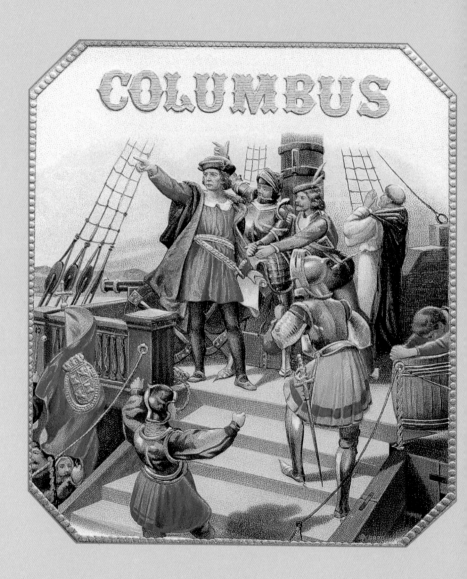

Famous explorers have also comprised a theme for the
designers of cigar-bands and cigar-box labels.

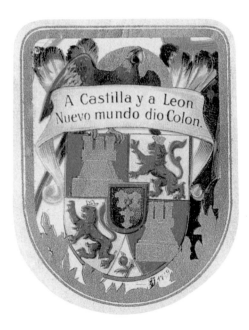

A Castilla y a Leon
Nuevo mundo dio Colon.

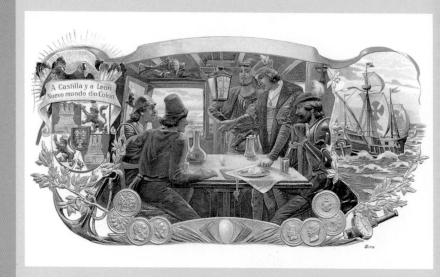

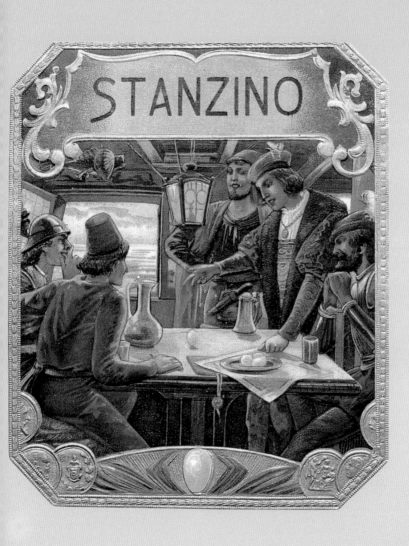

JUCUNDA

No one can say whether 'God smokes a Havana', but through their cigar-bands collectors may certainly be familiar with popes, angels, saints, and even the Buddha.

Epilogue

The cigar is well established, then, as an essential pleasure in the lives of people of taste. And that is as much due to the great variety in forms of satisfaction that it engenders. Robert T. Lewis has written:

Man has made war, has made love, has possibly suffered a little. [. . .] What else can he do for himself, in any brief space of time allowed to him, than experience the perfection of a cigar, the taste of the blue smoke which dissipates into the air as a symbol of the vanity of his works, of the impermanence of all things?

This and the following cigar-bands come from series that are now regarded as particularly fine and particularly hard to get hold of – such as the (Native American) 'Indian' series, emblematic of US tobacco merchandizers, and the 'Germany' series.

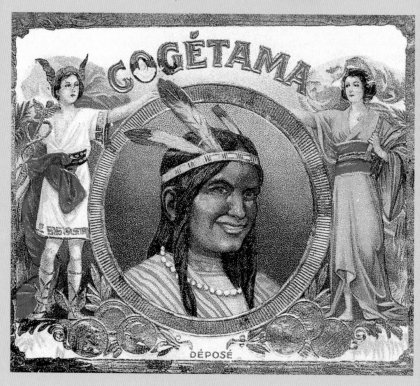

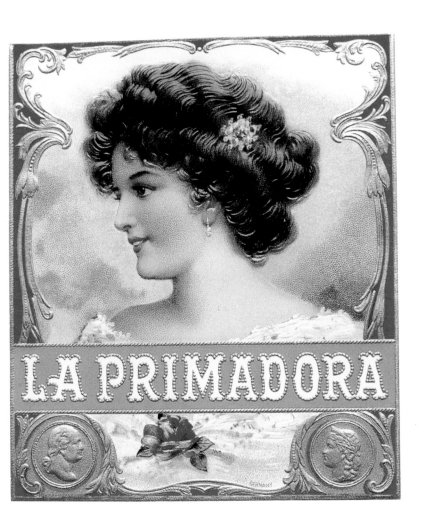

DEP N° 6874 ° VW

In this, he sums up very well what the pleasure of a cigar may mean.

A cigar may challenge the senses, may even excite them. To see one, to touch one – and euphoria may set in. True pleasure comes later when, having made himself master of its outer defences, the smoker proceeds to effect the incision and then to light up. Because he is an aesthete, because he knows that 'happiness comes step-by-step', he takes his time. He savours the precious moments spent studying the cigar, enjoying the anticipation of delights to come. He looks forward with pleasure to the adventure he is about to share with his cigar, far from the disappointing realities of the world, far from daily distractions and irritations – somewhere else altogether. Alone, or with his friends.

Alone, or with the one he loves.